The Hat

by Tomi Ungerer

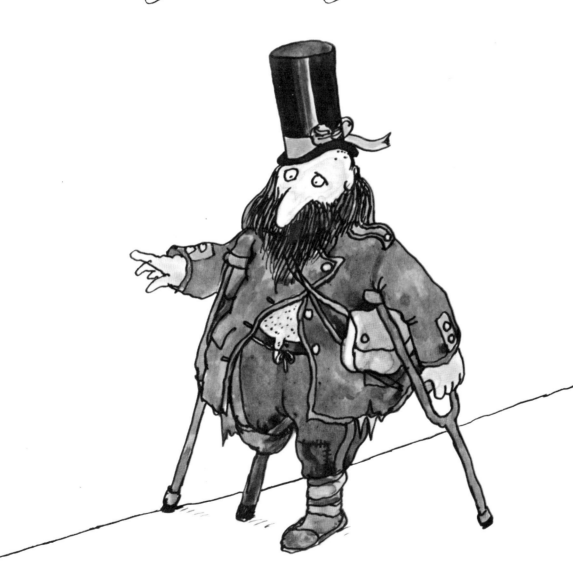

Parents' Magazine Press · New York

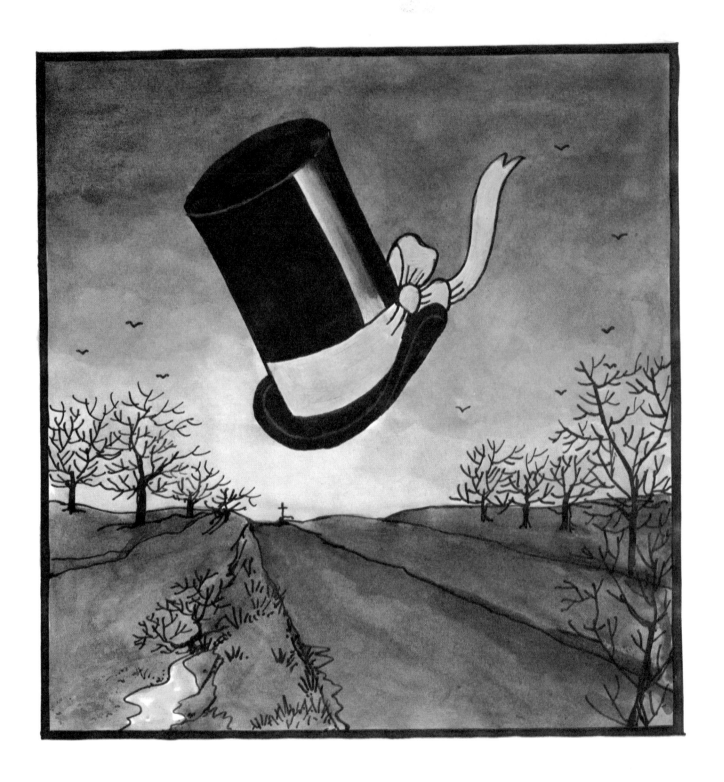

There was once a hat.
A tall black top hat, shiny as satin
and belted with a magenta silk sash.

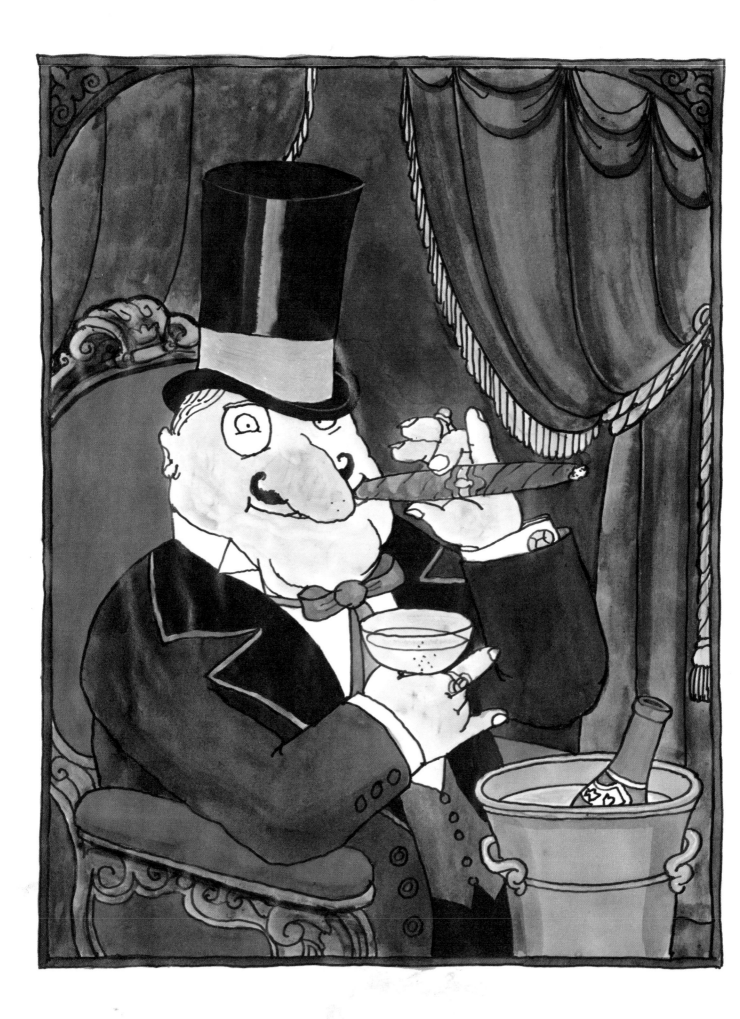

It lived happily on a rich man's head.
One day, speeding along in an open carriage,
the hat blew off.
"Never mind that hat, caro mio,"
said the rich man's fiancée. "We are already late."

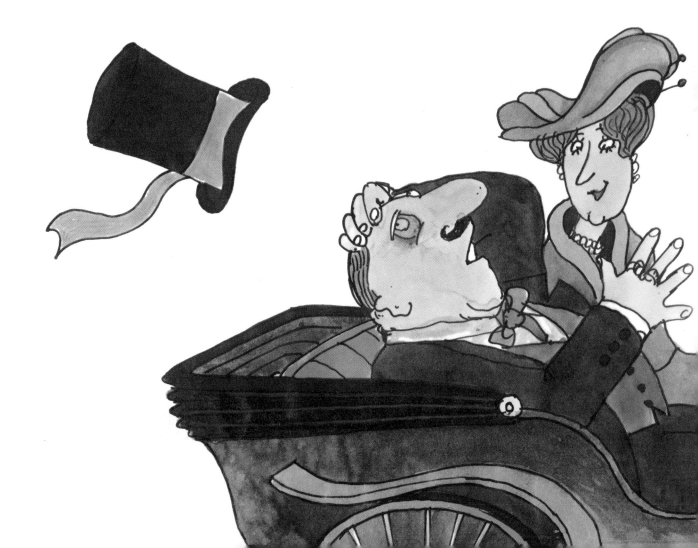

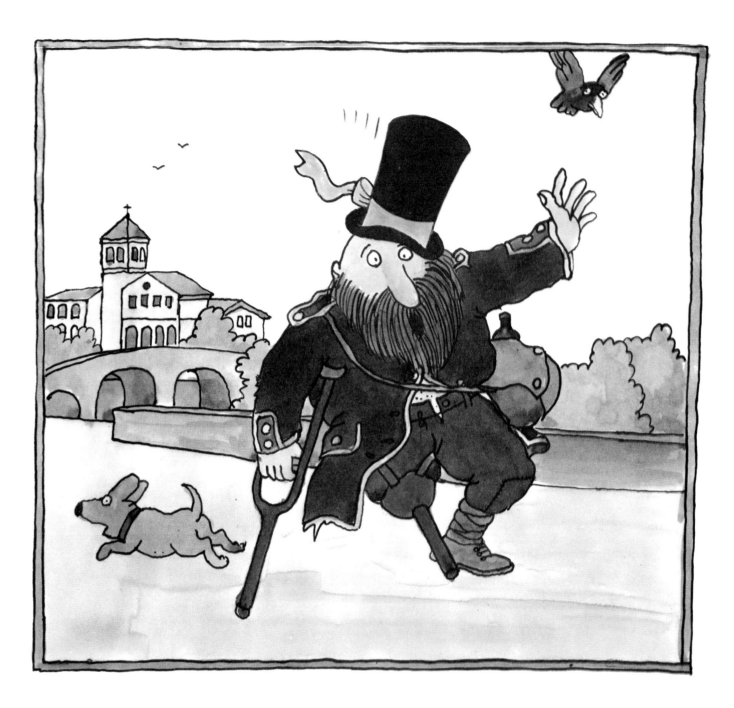

The wind blew, the hat flew,
hither and thither,
in loops and hoops
and landed at last on the bald head
of Benito Badoglio, a penniless veteran.
"Don't shoot, I surrender!" shouted
the bewildered old soldier.

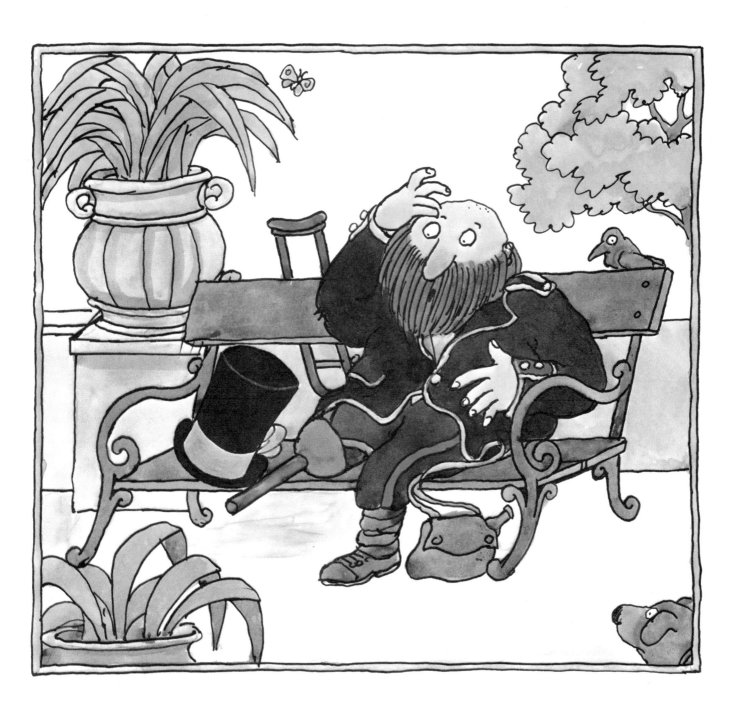

When he realized what had happened,
he sat down on a bench to examine the hat.
To his surprise, the hat popped out of his hands,
somersaulted and performed a little dance.
"Thunder of Sebastopole!" he cried.
"That hat is alive!
Come back, you crazy hat."

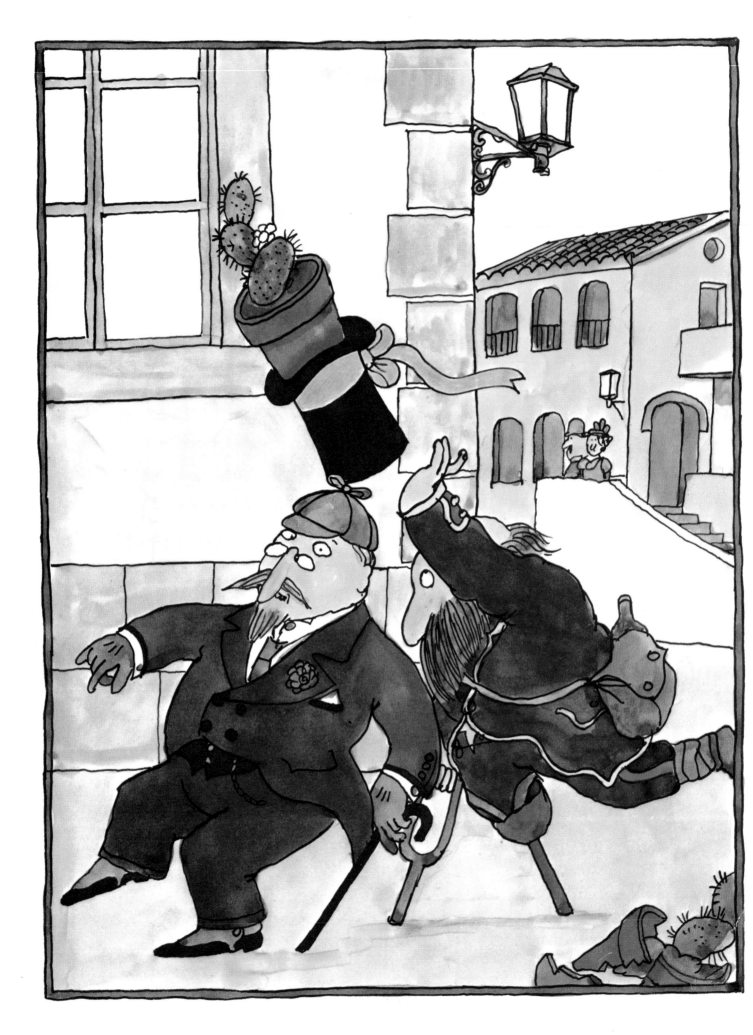

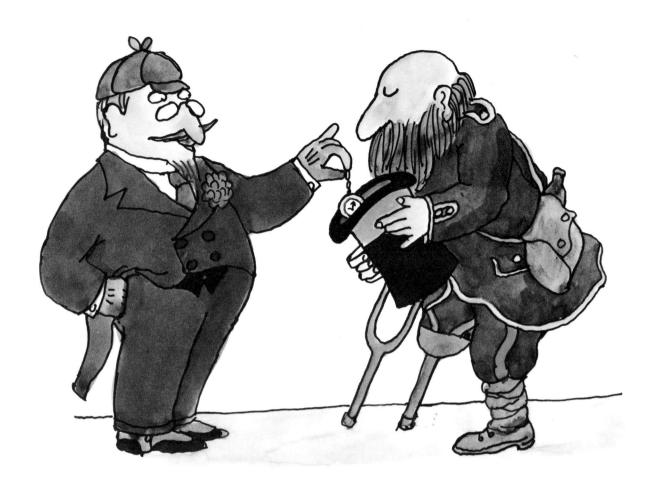

Lo and behold, the hat followed
his command and settled back on his shiny head.
Just then Badoglio saw a wealthy tourist
happily rambling down the street.
Suddenly a huge flowerpot
came tumbling down from a balcony above.
The hat went off in a flash and caught
the plant in midair.
"Well done, worthy old dragoon," said the foreigner.
"You saved my life. Now hold out your hat
and close your eyes." And the foreigner
filled the hat with banknotes and other valuables.
Badoglio was overwhelmed.

That same day posters appeared all over town.
Esmeralda had escaped! Esmeralda was a tiny, purple puffbird,
the only one in captivity. "One thousand millecentos
for the man who brings her back," cried the director
of the National Zoo. A huge crowd gathered at the pedestal
of Athena Aviatrix. There was Esmeralda
on top of the statue, out of reach.

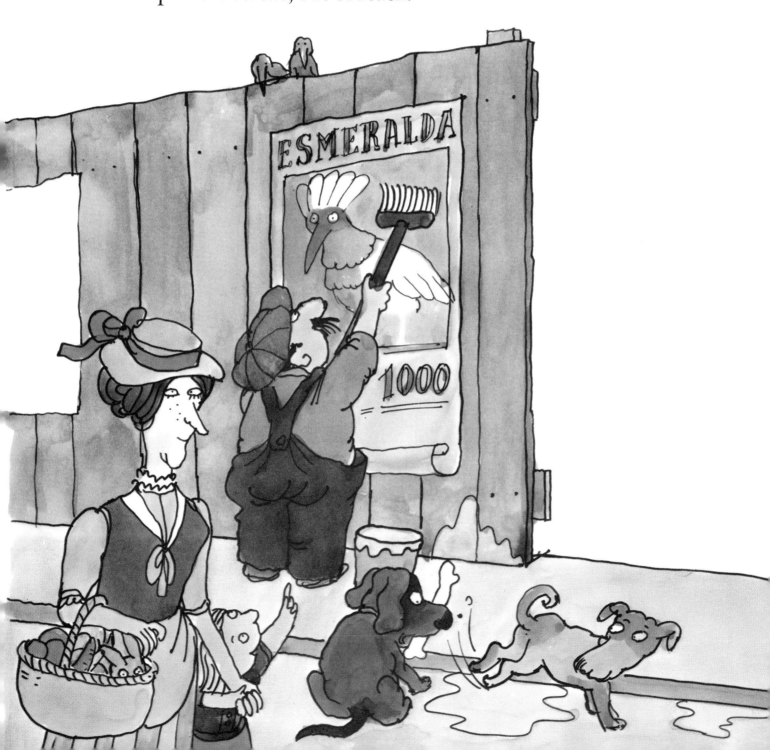

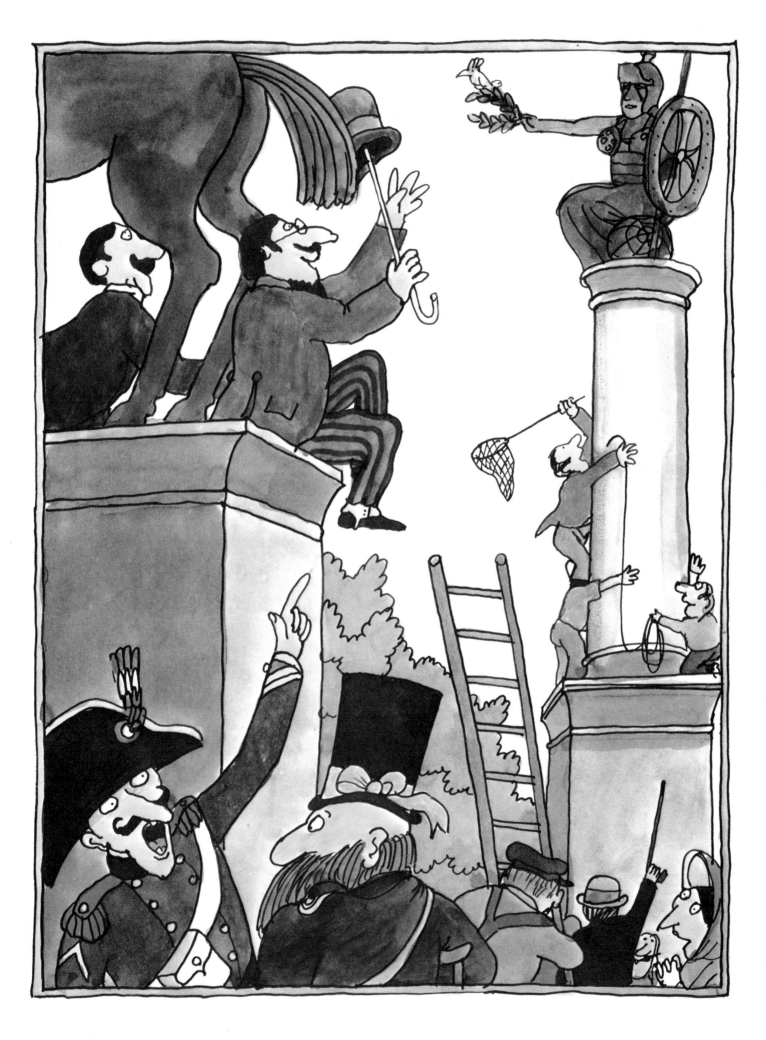

"Fetch!" ordered Benito. The hat obeyed.
It sailed off and swept up the bird
and returned to Benito.
The crowd cheered the miraculous performance.
The zoo director could not believe his eyes
when Badoglio uncovered his catch.
With his rewards, Benito Badoglio
bought clothing to match his hat.

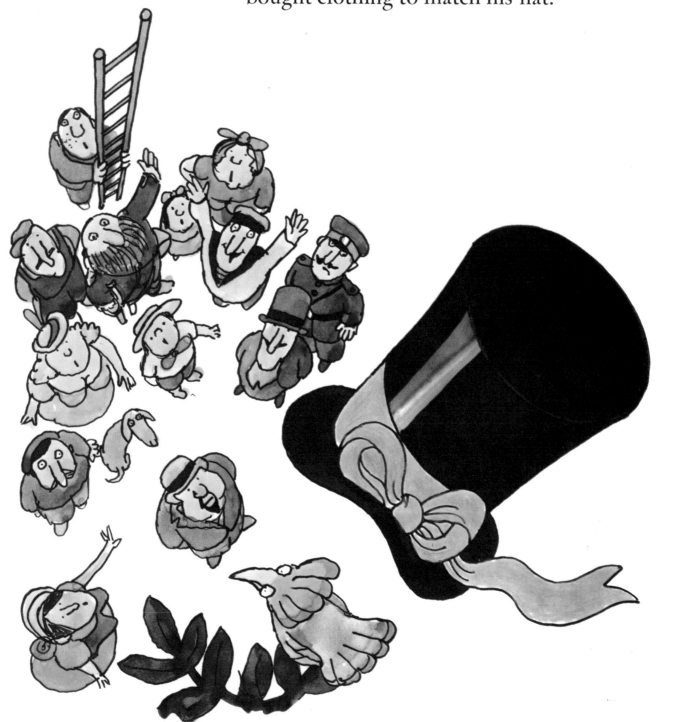

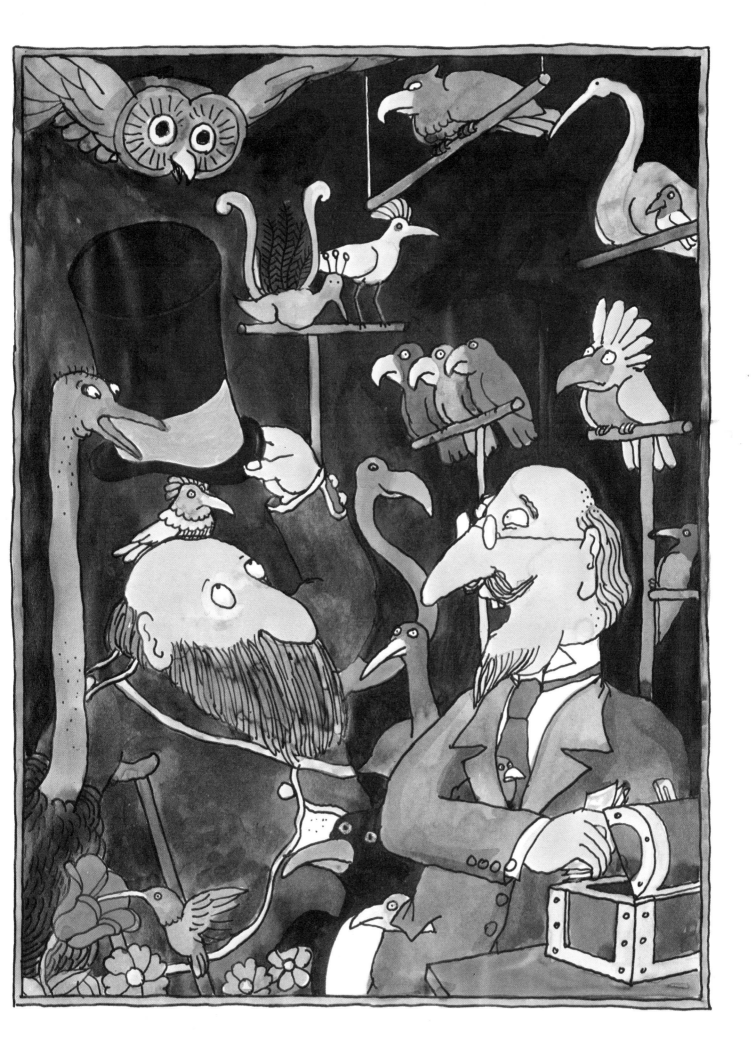

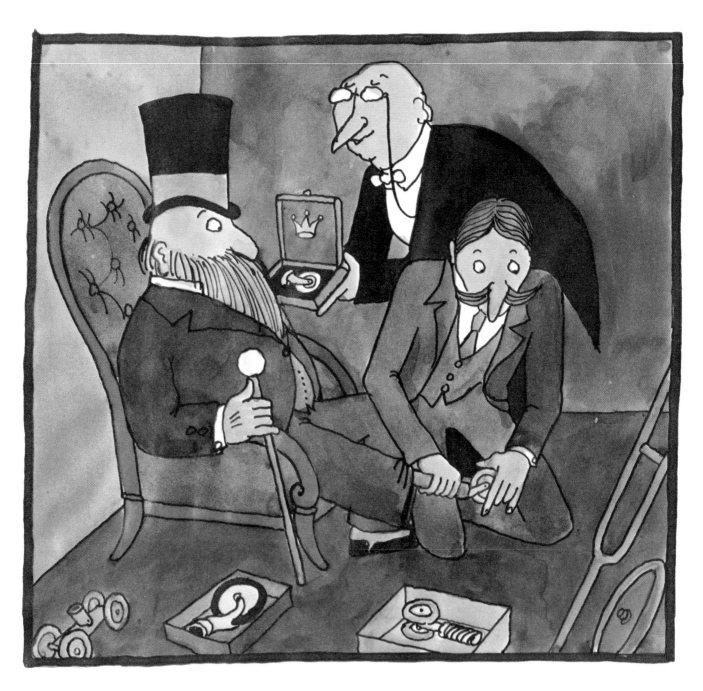

He had his peg leg fitted with a silver wheel.
He looked the perfect gentleman.
One afternoon as he was strolling and rolling
about the countryside, he was startled by the sound
of gunfire. "Solferino smoke! What is happening?"
he cried. "I smell gunpowder." The old soldier revived
in Benito Badoglio and he rushed to the scene of action.

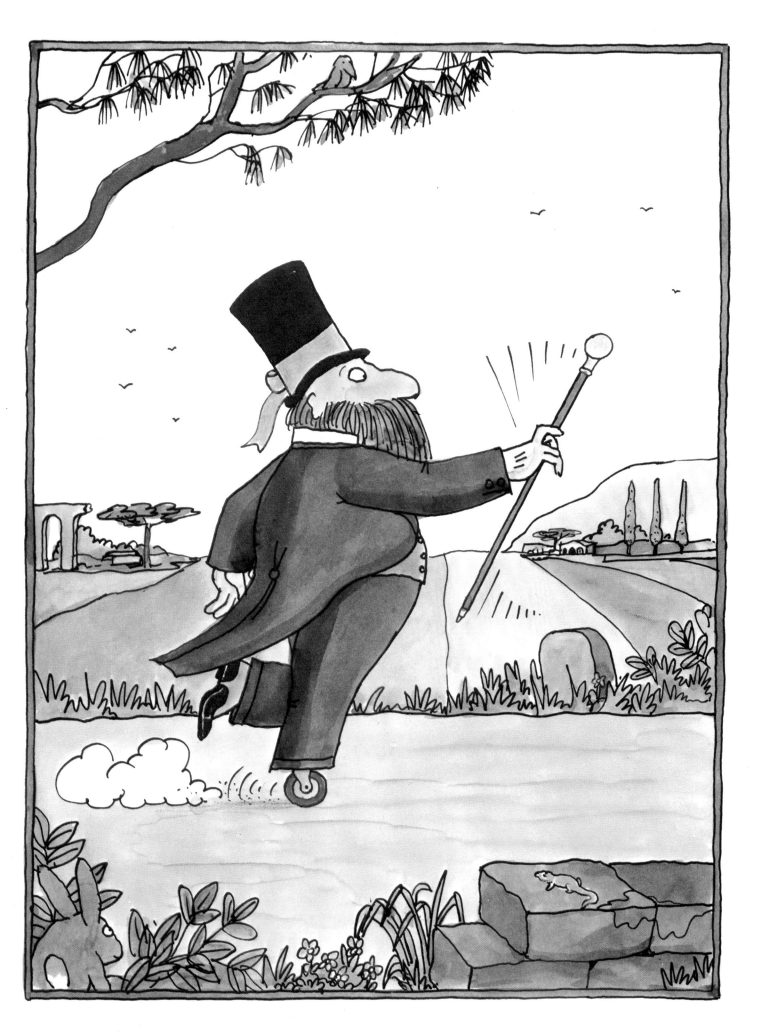

Soldiers and policemen were lined along the road.
A battery aimed at a little farmhouse was on the ready.
Badoglio recognized one of the officers.
"Capitano Mallamorte!" he cried. "What is this all about!"
"We have trapped a band of cutthroats in their lair,"
replied the captain. "They refuse to surrender.
Our cannon will soon blow their brains to reason."

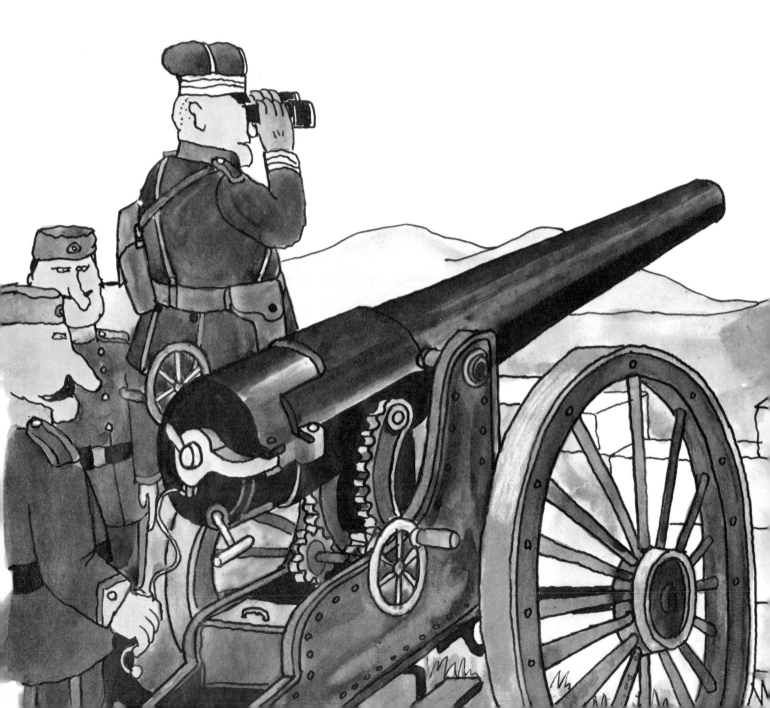

"Don't shoot yet. Put me in charge and you shall
capture them alive. Hat, hat!" ordered Badoglio.
"To the chimney, quick!"
The hat took off and settled on top of the flue.
Soon a white flag appeared.
In clouds of smoke the brigands staggered out,
one by one, coughing and choking.

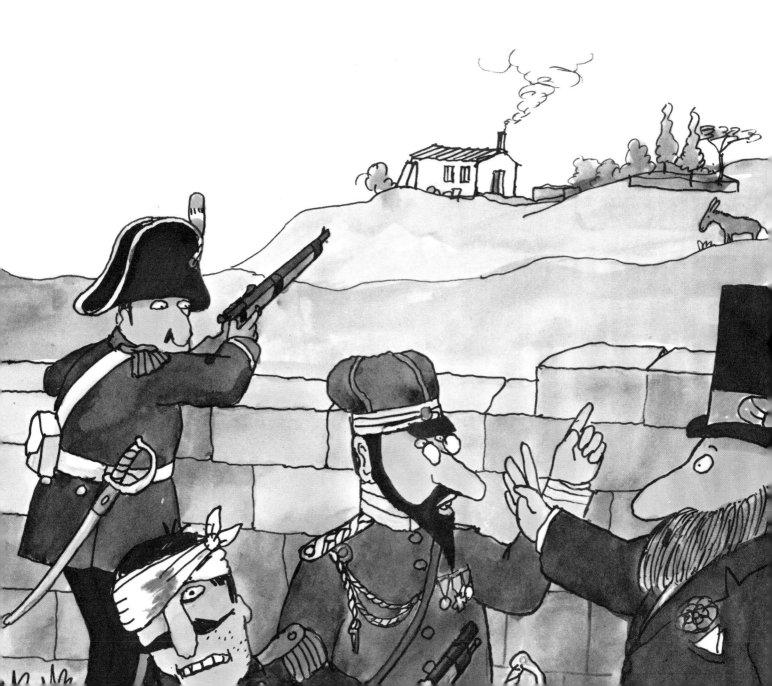

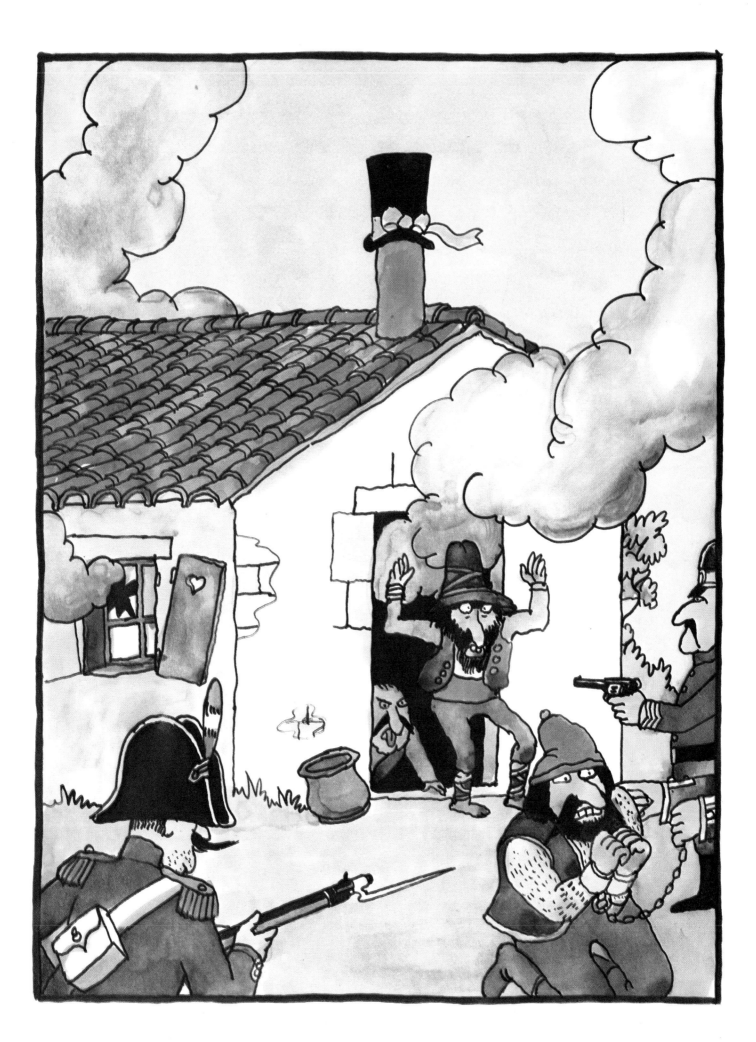

The next morning, as he was reading in the paper about his latest exploits, Badoglio noticed a dashing cadet entertaining a young mother with fresh gossip. Meanwhile, he was shaking the ashes of his fat cigar into the baby carriage.

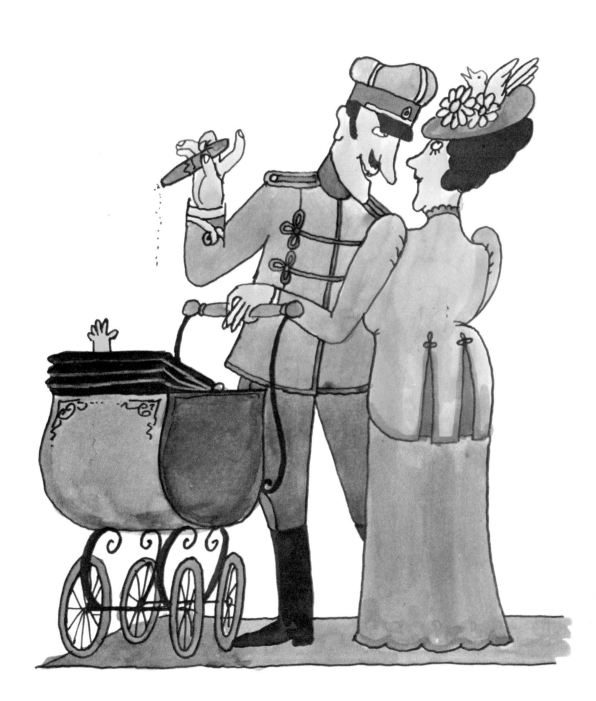

The pram went up in flames.
Terrified by the blaze, the mother let go
of the carriage. Down, down it went,
down the endless steps
of the Messalina Prospect.
Benito Badoglio saw it all.

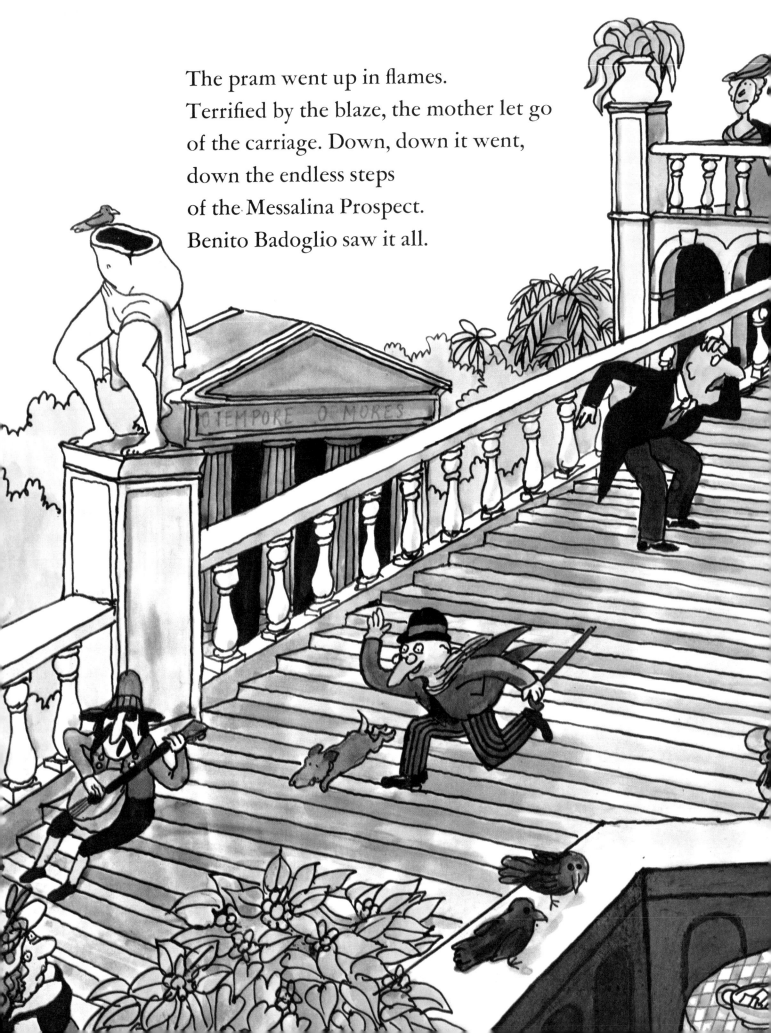

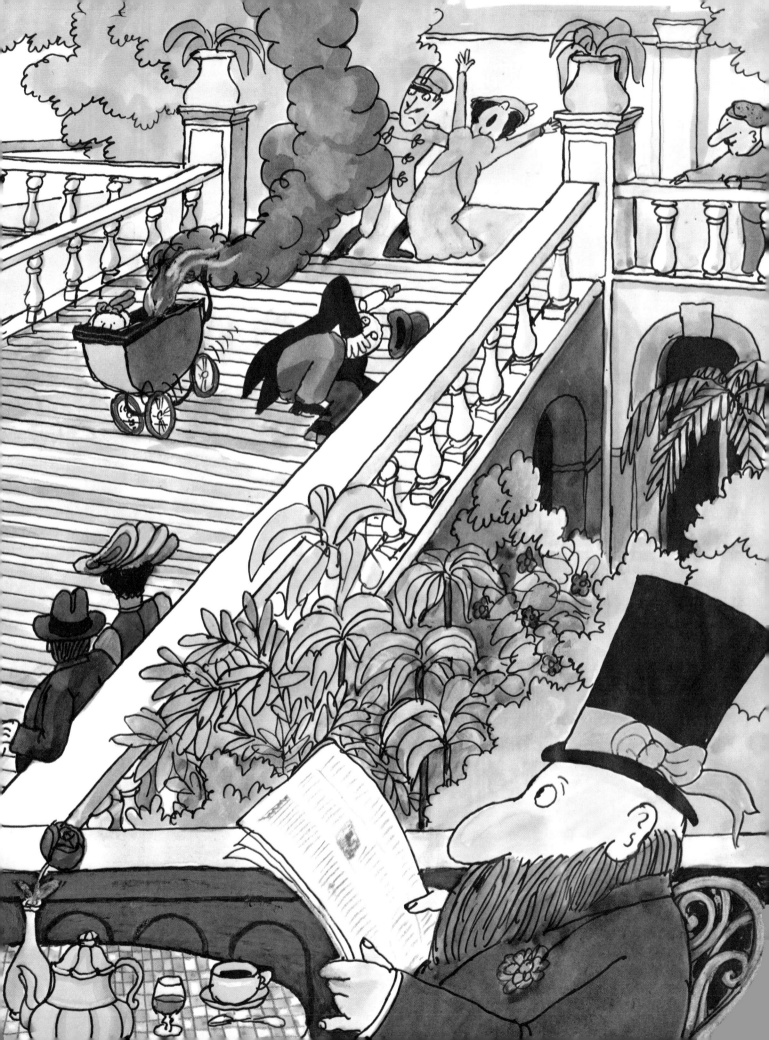

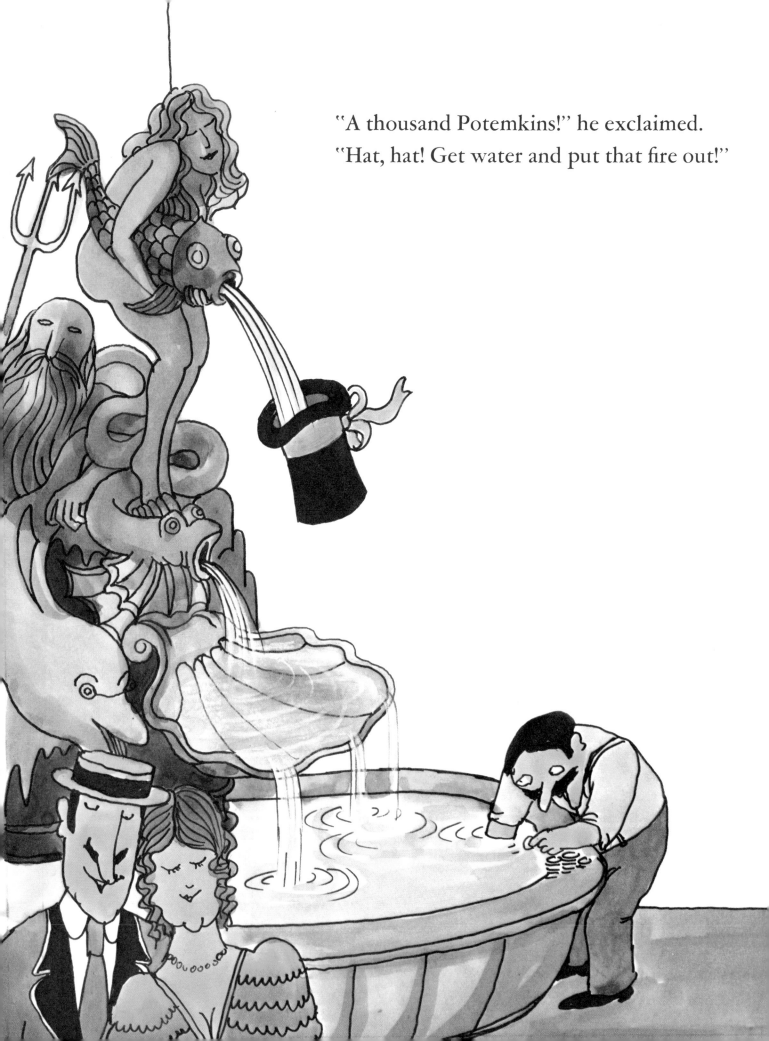

"A thousand Potemkins!" he exclaimed.
"Hat, hat! Get water and put that fire out!"

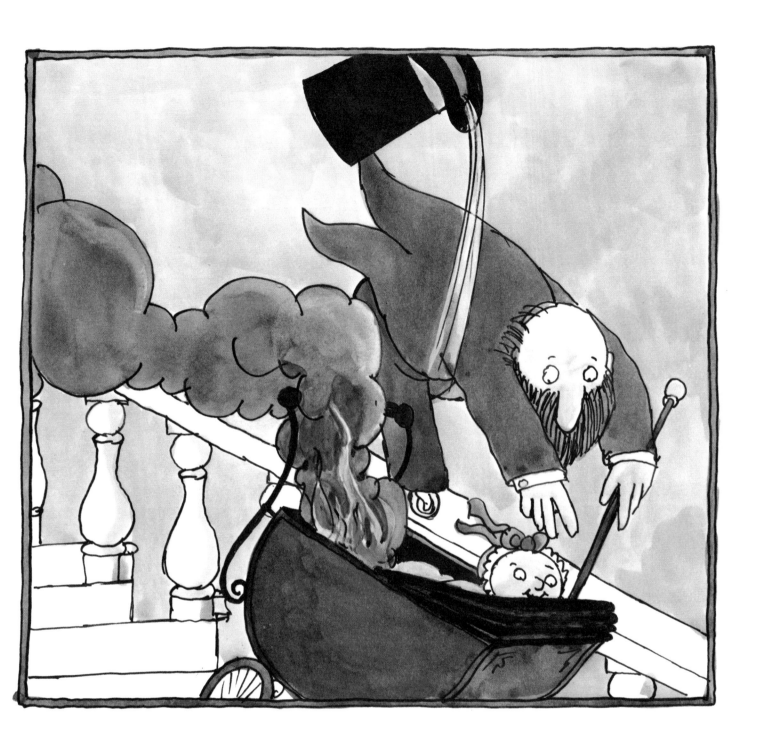

No sooner said than done, for there was a fountain nearby.
Rolling down the balustrade, our hero caught and stopped
the doomed carriage as water from the hat poured in.

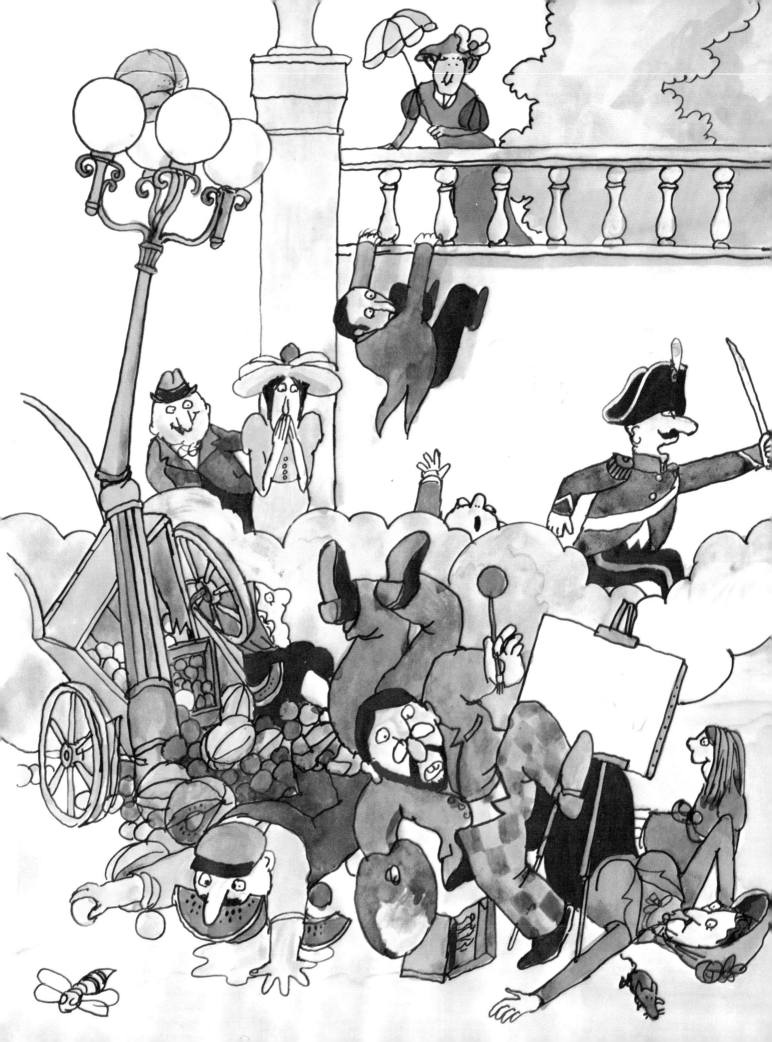

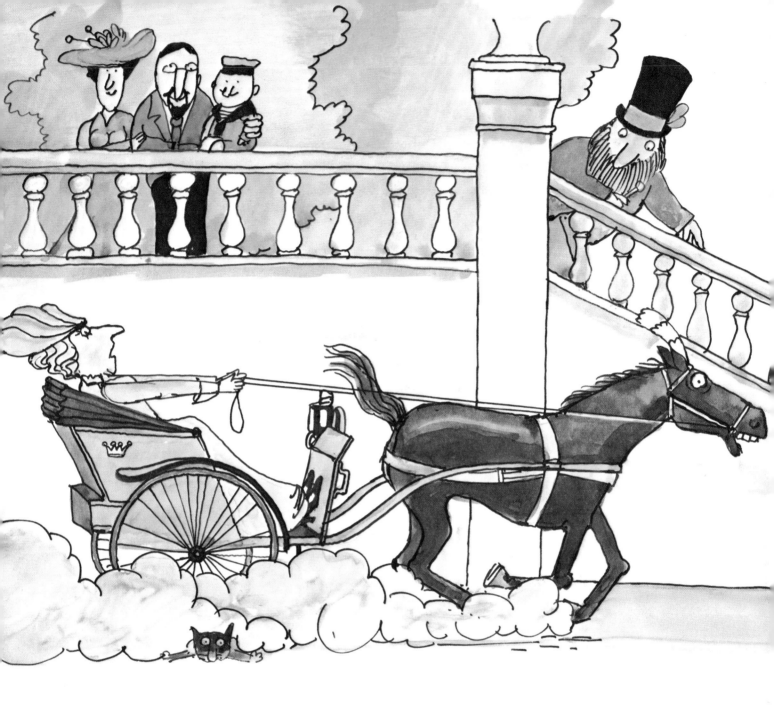

Mr. Badoglio was just catching his breath when a horse, stung by a hornet, came running amuck. Many people had already been hurt. The panic was total.

The bolting horse was harnessed to a tilbury, driven by the Contessa Aspi d'Istra, a sister-in-law of the Archduke. The Contessa was howling with fright.

Without waiting for orders, the hat leapt straight for the nag's
head. It was just big enough to cover the horse's eyes.
The horse was blinded and stopped in front of Badoglio,
who caught the fainting Contessa in his arms.
She soon regained her senses. "Who are you, valiant savior?"
"Benito Badoglio, at your service, noble lady," he said.
"I must thank you for your gallant rescue. Please get me back
to the Archduke's castle. I want him to meet you."
"What a lovely lady," Benito thought as he rolled along.

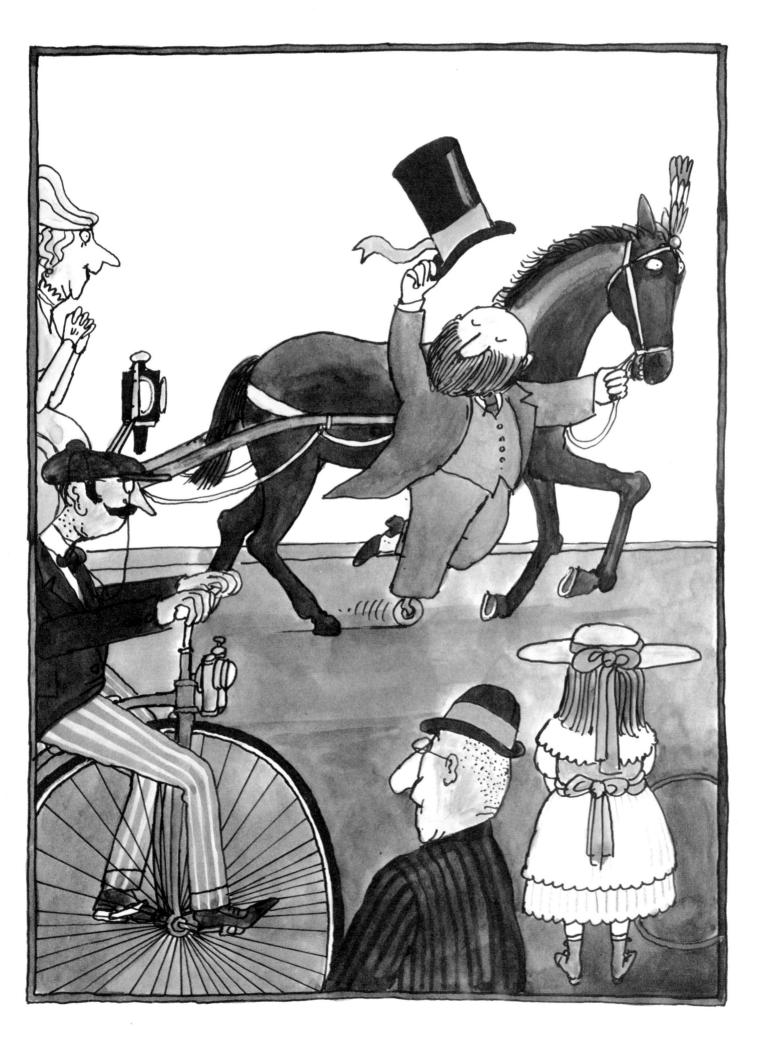

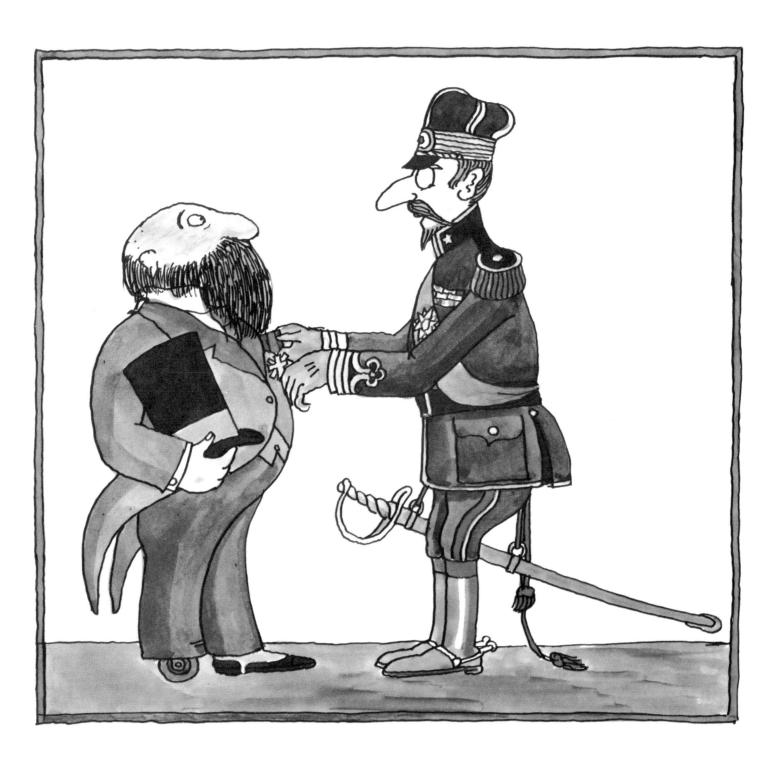

The Archduke was most pleased to meet the hero all the papers
were raving about. Badoglio was decorated on the spot, and he
was named Minister of National Emergencies.
The next day Badoglio sent the Contessa some roses.

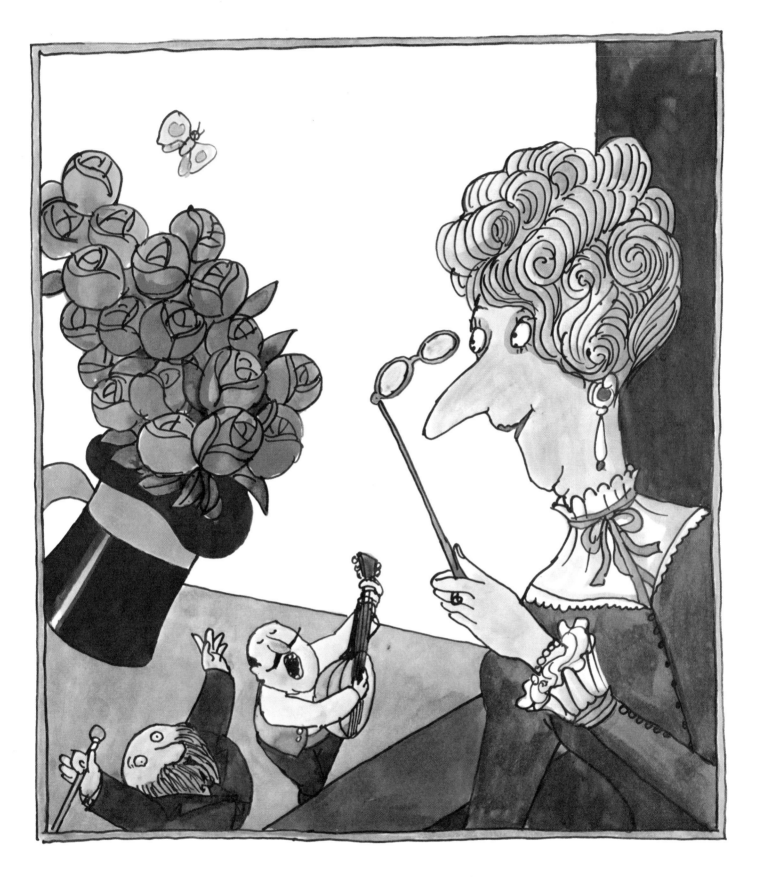

She was thrilled and charmed.
He was in love, she fell in love.

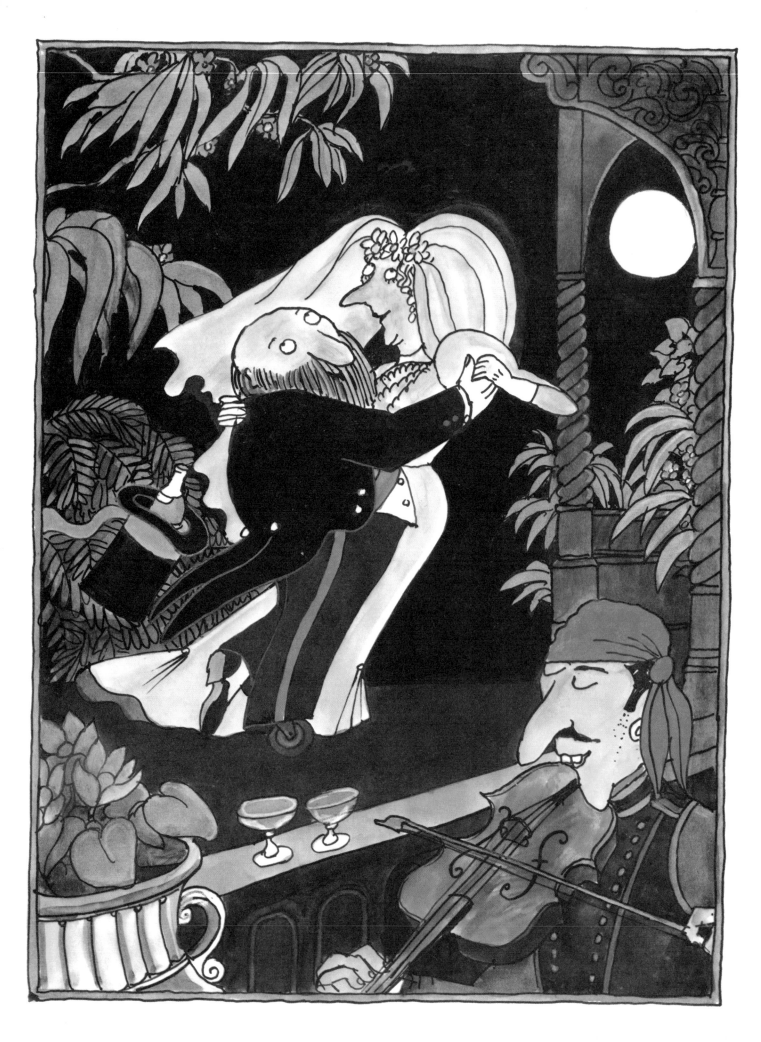

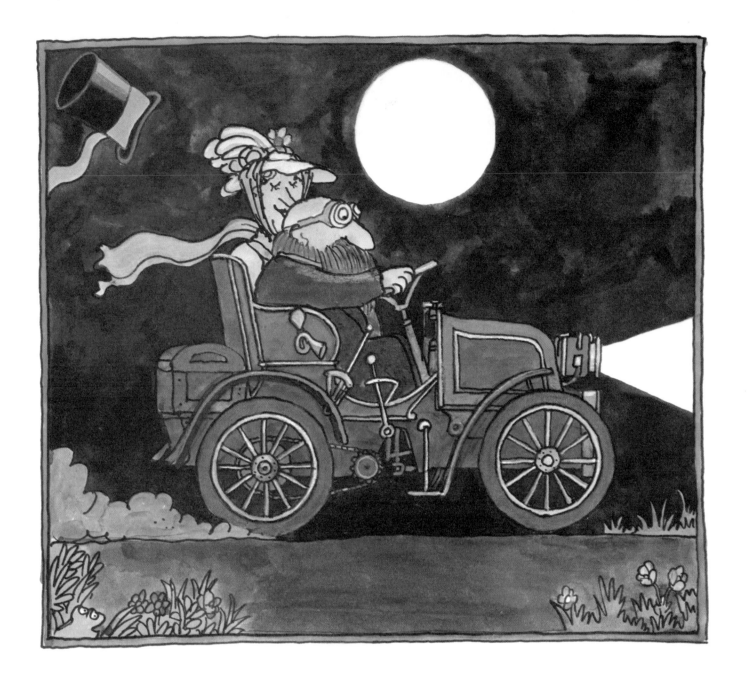

Soon a splendid wedding took place. Badoglio and his bride
danced in a rapture all evening. At midnight they left—
singing in the moonlight—for a honeymoon in Sardinia.
They were speeding along in an open car...his hat blew off...
"Never mind the hat, caro mio," said the Contessa.
"I should like to get there by sunrise."

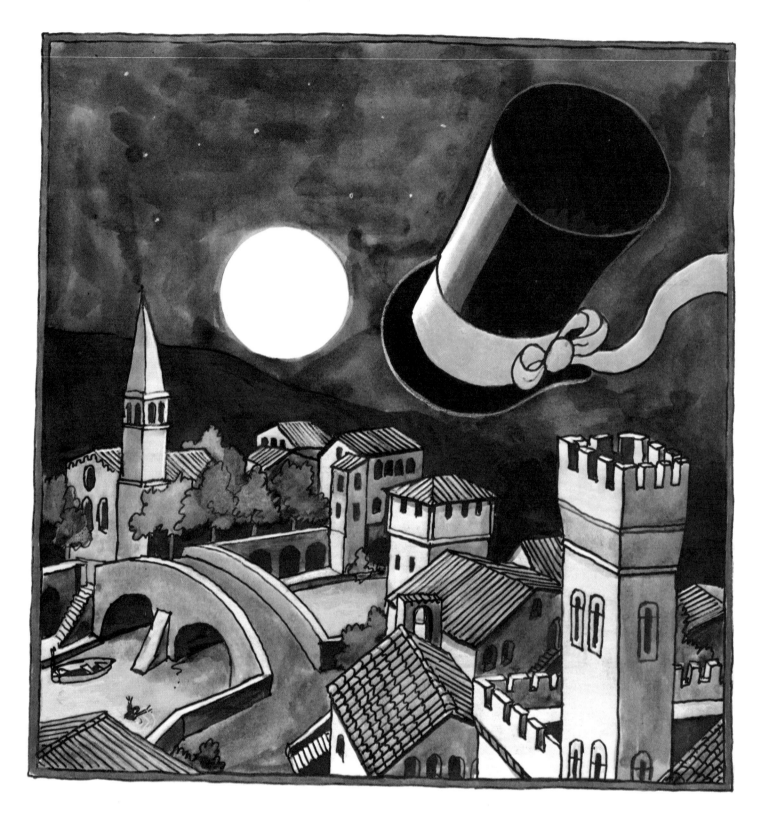

The wind blew, the hat flew,
hither and thither . . .
Heaven only knows where.